b 12711858

CINDY SHERMAN
A PLAY OF SELVES

CINDY SHERMAN
A PLAY OF SELVES

Metro Pictures, New York
Sprüth Magers, Cologne / Munich / London

INTRODUCTION

This is the only work I've ever done that was consciously autobiographical. It's embarrassing to look back, especially at this work that was so personal, so raw. It's corny, sincere, and obvious, yet makes so much sense in how my work has developed, the similarities as well as differences.

I first used cut-out figures for an animated film (*Doll Clothes*, 1975) of a paper-doll of myself. Once the characters were cut up I realized they could interact with one another—now Photoshop makes all this seem quaint.

I don't remember exactly how I thought of splitting myself into these characters, if I had started with one scene and then the story grew or if I had thought of it in one whole package. But it amazes me how orderly and ambitious a project it was. I don't know if I was aware how much this was like planning a film.

I laid out a shooting schedule so that when I would do each character I could consecutively shoot each corresponding scene. Then I had to plan a printing schedule, figure out the various scales for foreground, middle ground, background, etc., as well as accounting for gender—so that once I had the enlarger set up to a particular size I could print everything for that scale. And then came the enormous task of cutting. I had a lot more time on my hands in those days.

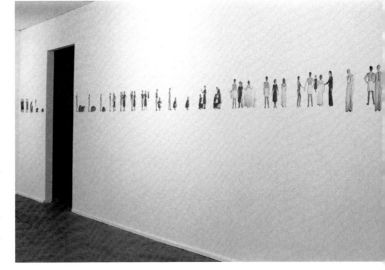

When I moved to New York City, I didn't want to cut any more photos so I had to come up with another way to insinuate a story. That's when the *Untitled Film Stills* began.

The only other time this work has been seen, was in 1976 at Hallwalls, the alternative gallery space in Buffalo, New York, while I was finishing up my last year in college.

Cindy Sherman

EINLEITUNG

Von allen Arbeiten, die ich je gemacht habe, war diese die einzige bewusst autobiografische. Zurückzublicken macht einen verlegen, besonders auf diese Arbeit, die so persönlich, so roh ist. Sie ist altmodisch, aufrichtig und sonnenklar und doch so sinnfällig dafür, wie mein Werk sich entwickelt hat, in den Ähnlichkeiten so sehr wie in den Unterschieden.

Ausgeschnittene Figuren verwendete ich erstmals für einen Animationsfilm über eine Papierpuppe meiner selbst *(Doll Clothes*, 1975). Sobald die Charaktere ausgeschnitten waren, ging mir auf, dass sie miteinander interagieren könnten – angesichts von Photoshop wirkt das heute alles putzig.

Ich erinnere mich nicht genau, wie ich auf den Gedanken kam, mich in diese Charaktere aufzuspalten, ob ich mit einer Szene anfing, die sich dann zu einer Geschichte auswuchs, oder ob ich mir das Ganze in einem Zug ausgedacht habe. Aber ich bin erstaunt, wie methodisch und ehrgeizig dieses Projekt war. Ich weiß nicht, ob mir bewusst war, wie sehr dies der Planung eines Films entsprach.

Ich legte einen Aufnahmeplan fest, sodass ich, wenn ich den jeweiligen Charakter darstellen würde, die entsprechende Szene in Folge aufnehmen konnte. Dann musste ich die Anfertigung der Abzüge planen, die Maße für die Staffelung in Vorder-, Mittel- und Hintergrund und so weiter

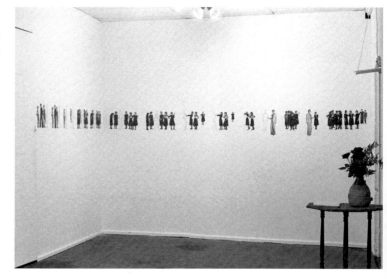

ermitteln und dabei auch die Geschlechterrolle berücksichtigen – sodass ich, sobald der Vergrößerer eingerichtet war, alle Abzüge einer bestimmten Größe auf einmal machen konnte. Anschließend kam die riesige Aufgabe des Ausschneidens auf mich zu. Ich hatte damals sehr viel mehr Zeit.

Als ich nach New York City zog, wollte ich keine Fotos mehr schneiden und musste mir ein anderes Verfahren ausdenken, wie ich eine Geschichte andeuten könnte. Da kamen dann die *Untitled Film Stills* ins Spiel.

Zu sehen war diese Arbeit nur ein einziges Mal, 1976 in Hallwalls, dem alternativen Galerieraum in Buffalo, New York, als ich mein Abschlussjahr am College absolvierte.

Cindy Sherman

A PLAY OF SELVES

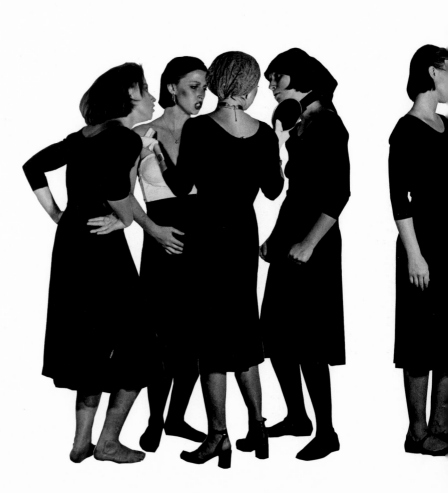

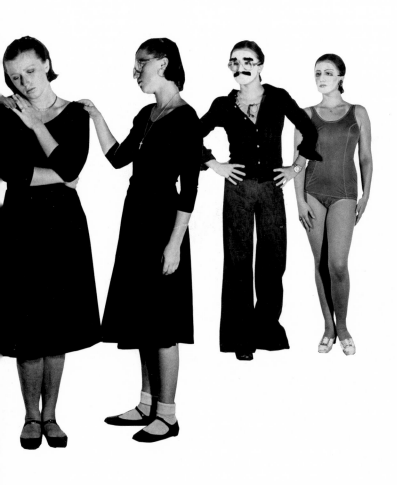

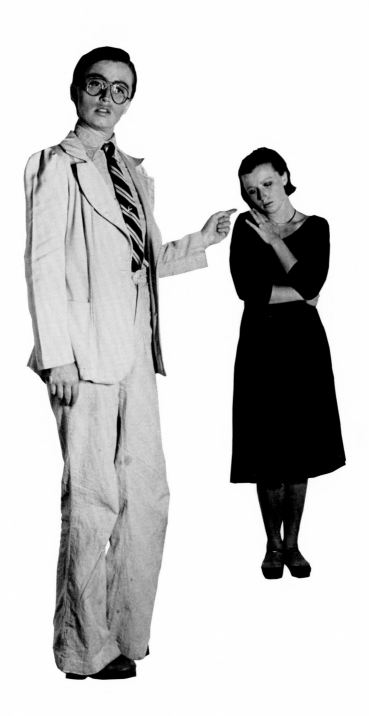

ACT 1 – 2

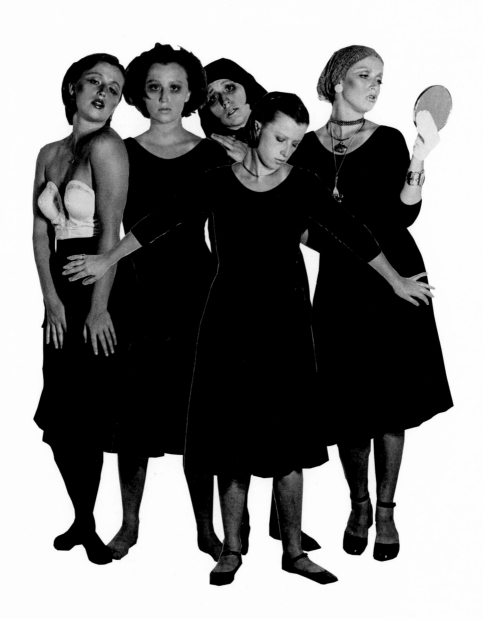

ACT 1 – 3

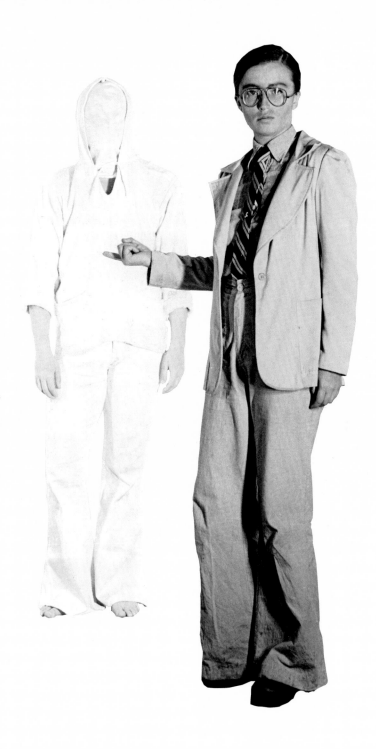

ACT 1 – 4

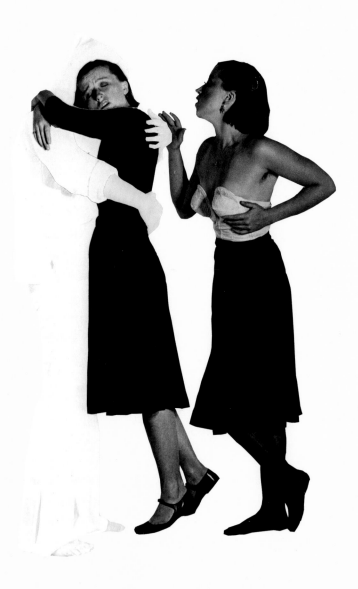

ACT 1 – 5

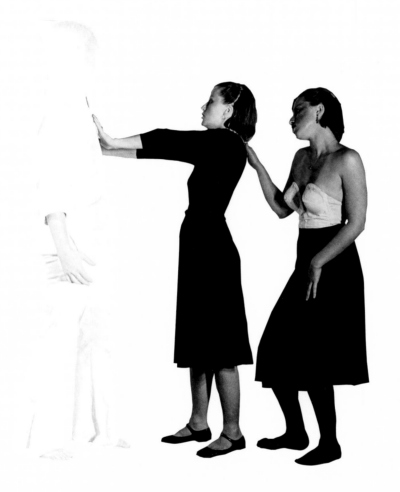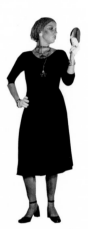

ACT 1 – 6

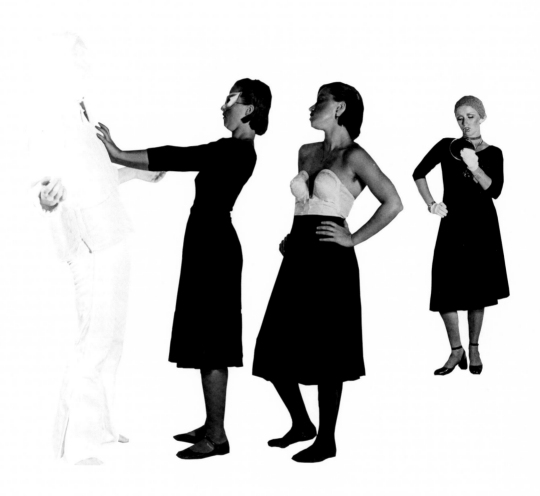

ACT 1 – 7

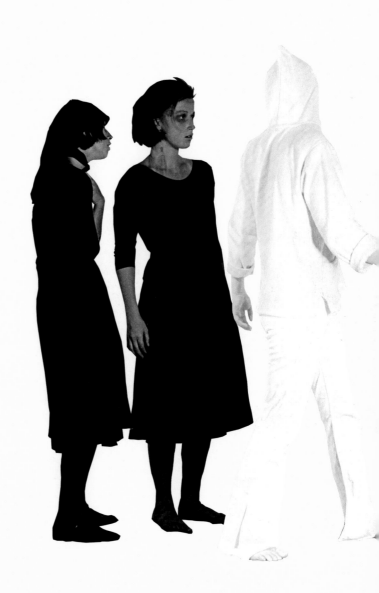

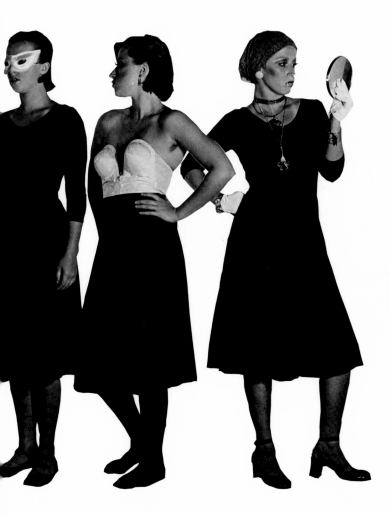

ACT 1 – 8

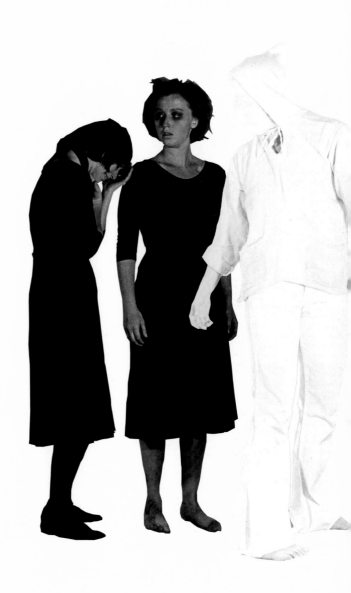

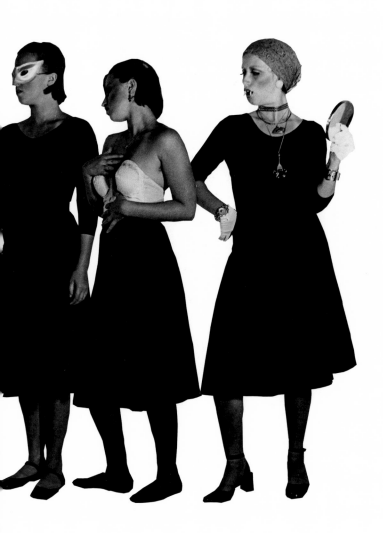

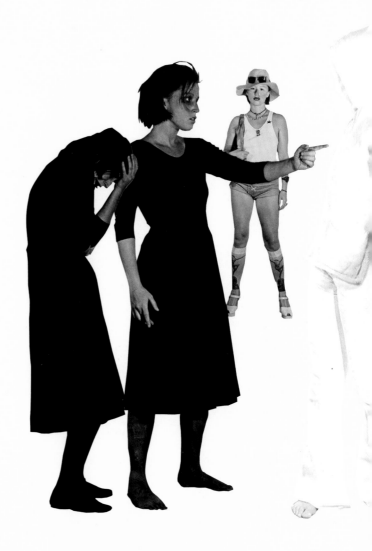

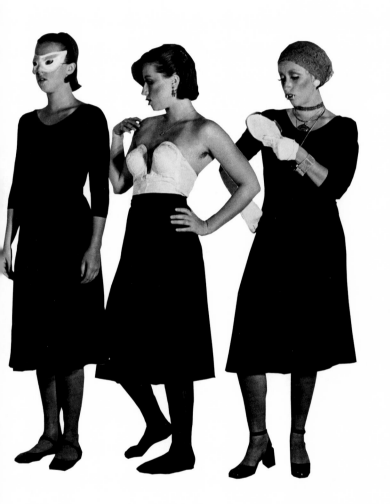

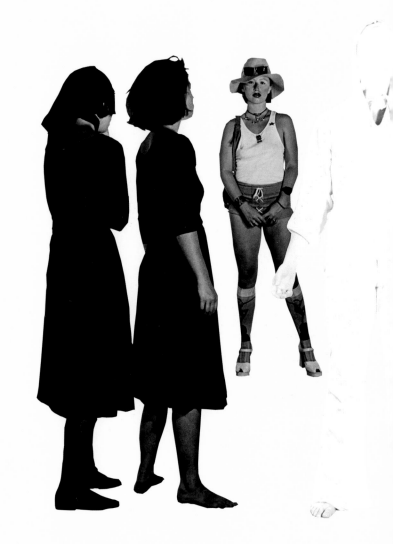

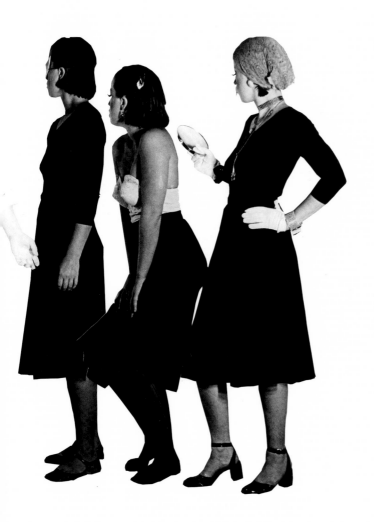

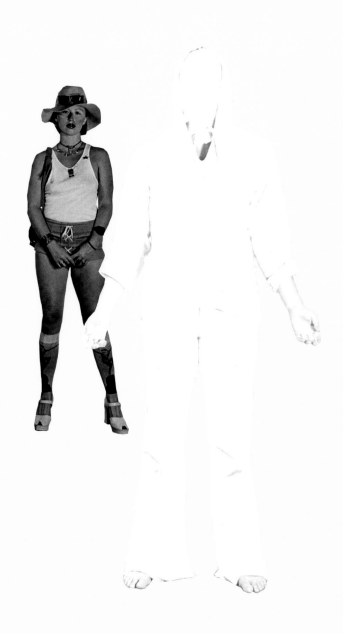

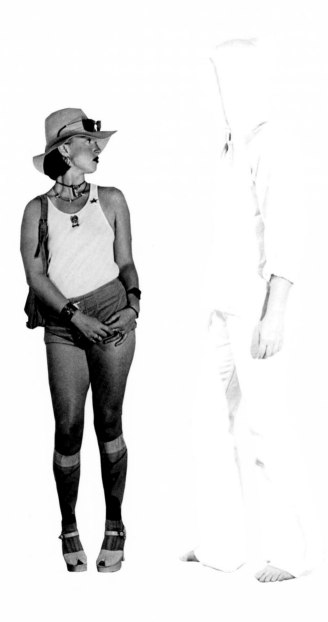

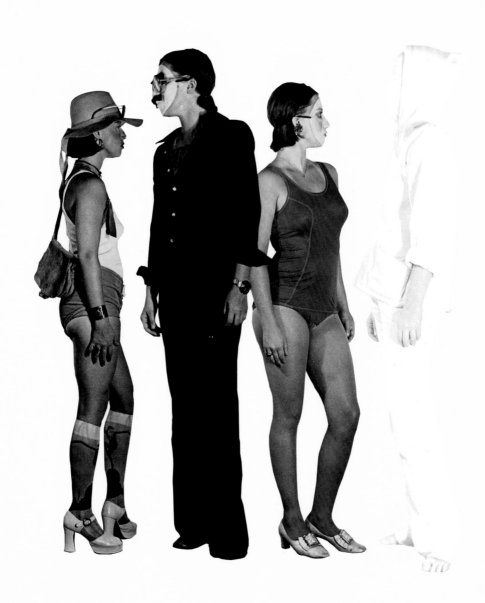

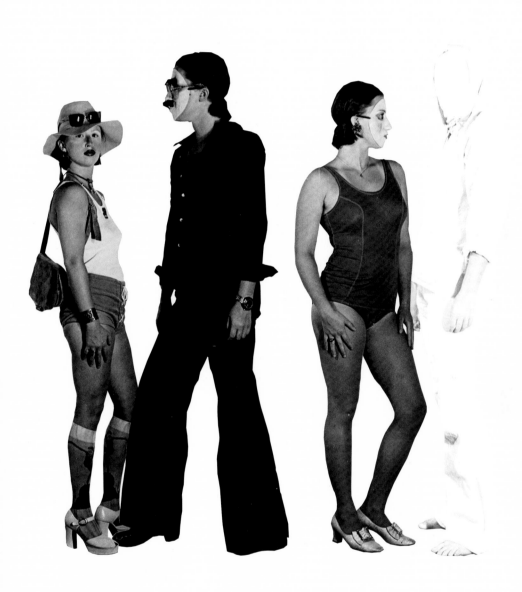

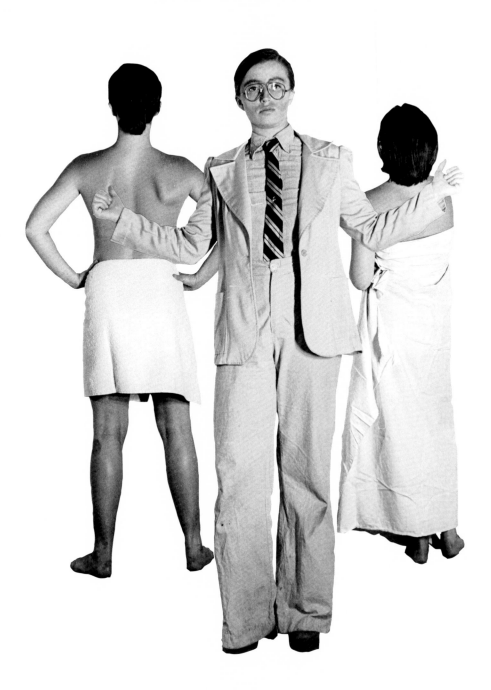

ACT 2 – 1

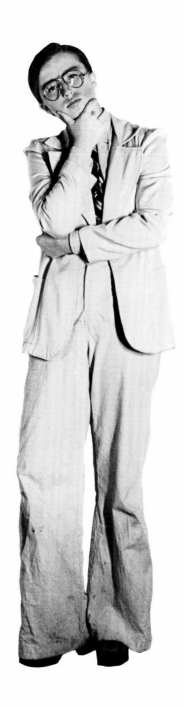

ACT 2 - 2

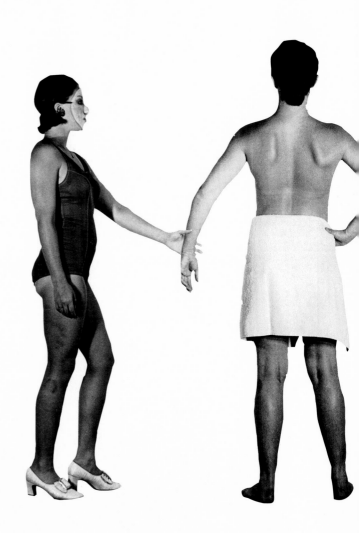

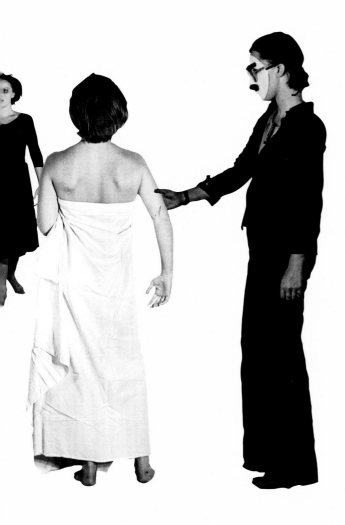

ACT 2 – 3

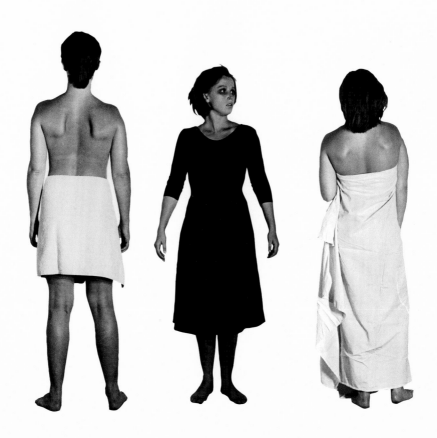

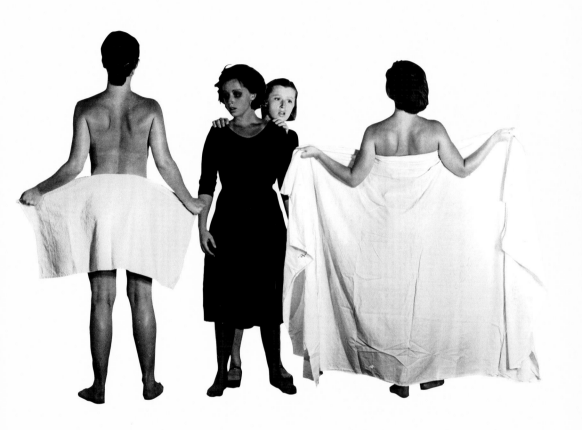

ACT 2 – 5

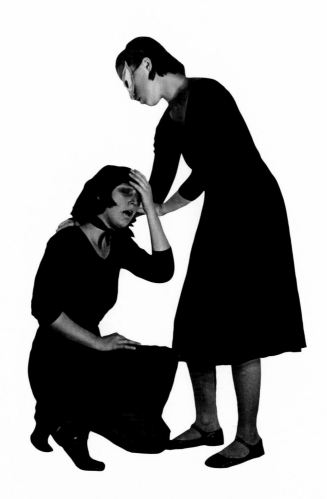

ACT 2 – 6

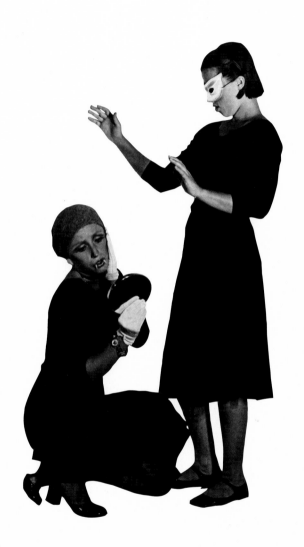

ACT 2 – 7

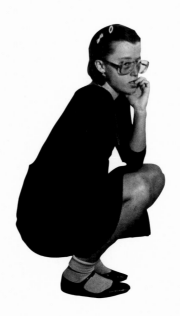

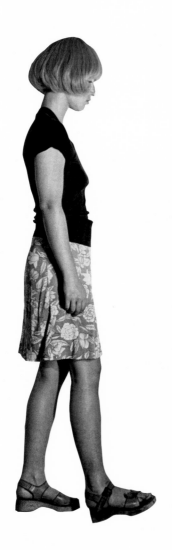

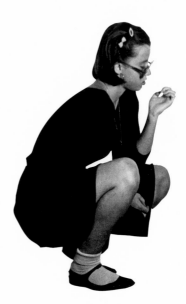

ACT 2 – 9

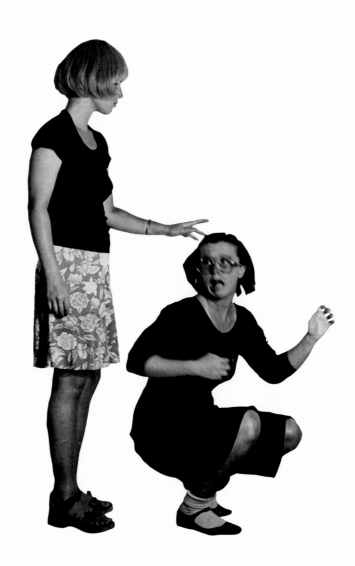

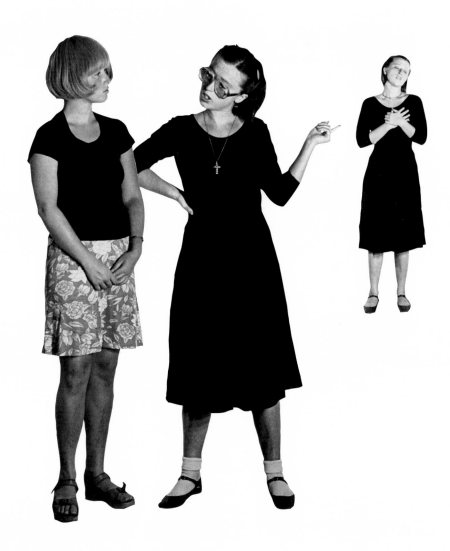

ACT 2 – 11

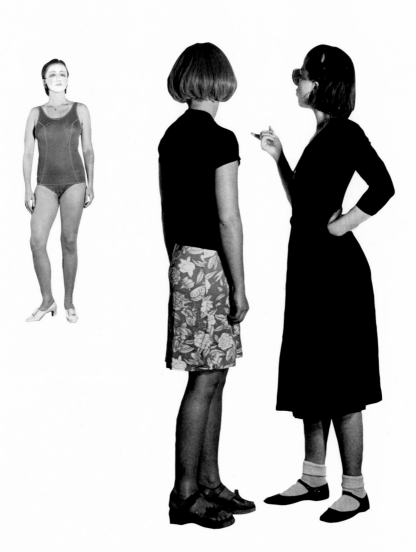

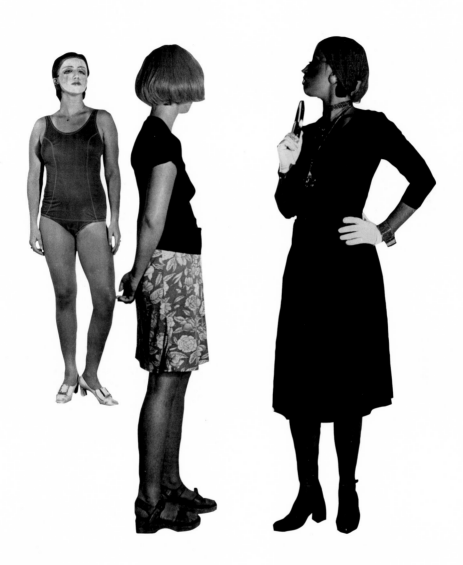

ACT 2 – 13

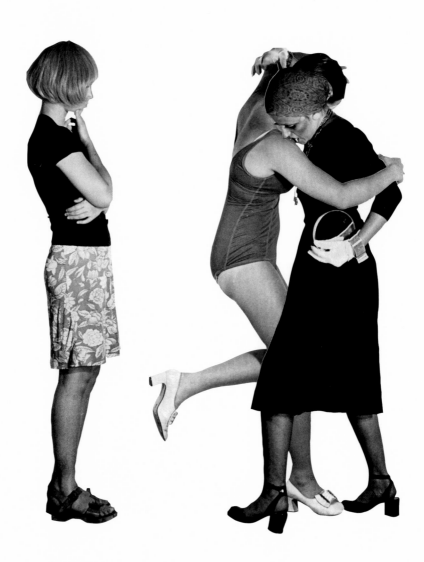

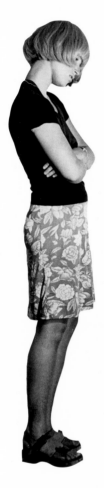

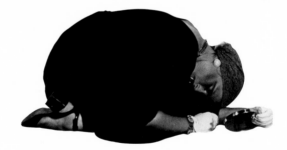

ACT 2 – 15

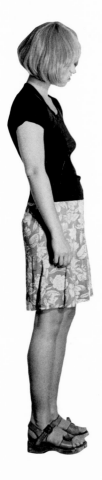

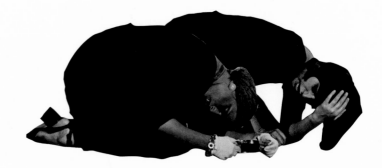

ACT 2 – 16

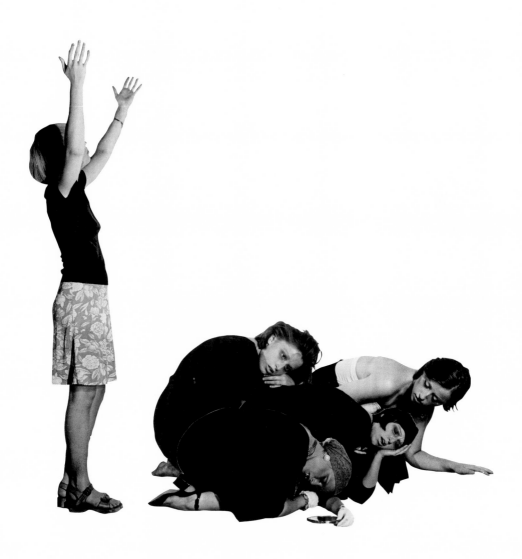

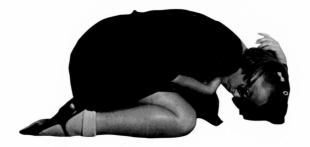

ACT 3 – 1

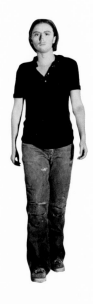

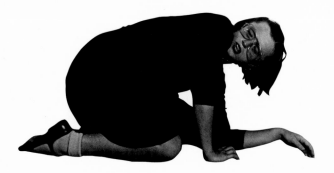

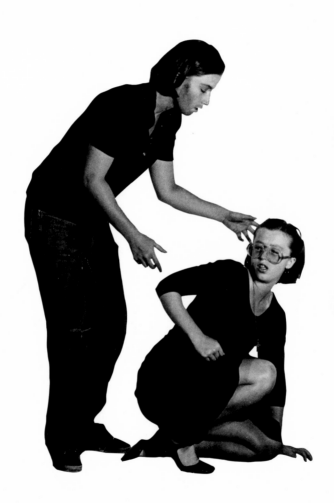

ACT 3 – 3

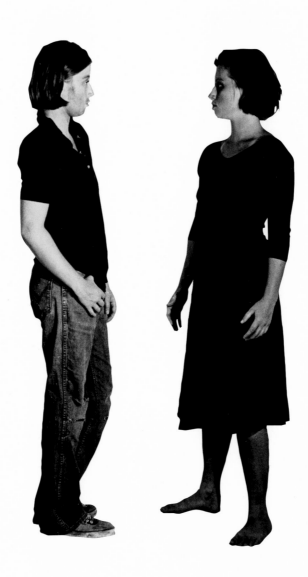

ACT 3 – 4

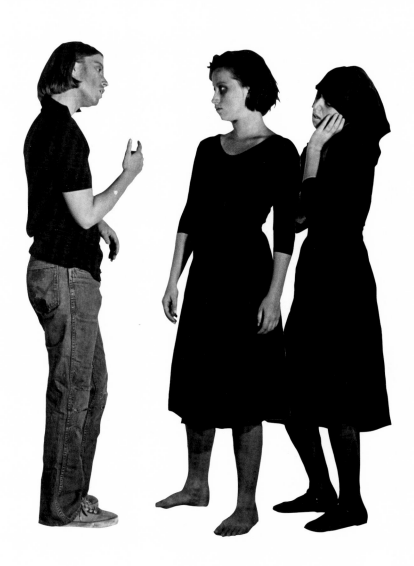

ACT 3 – 5

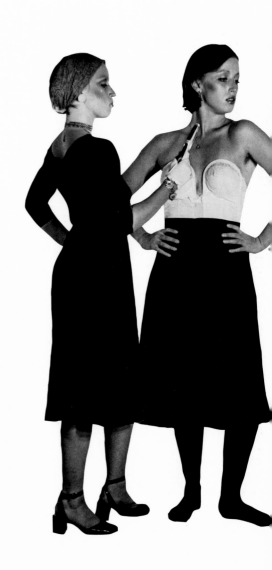

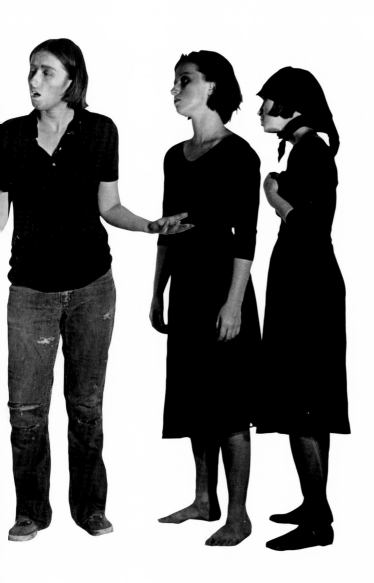

ACT 3 – 6

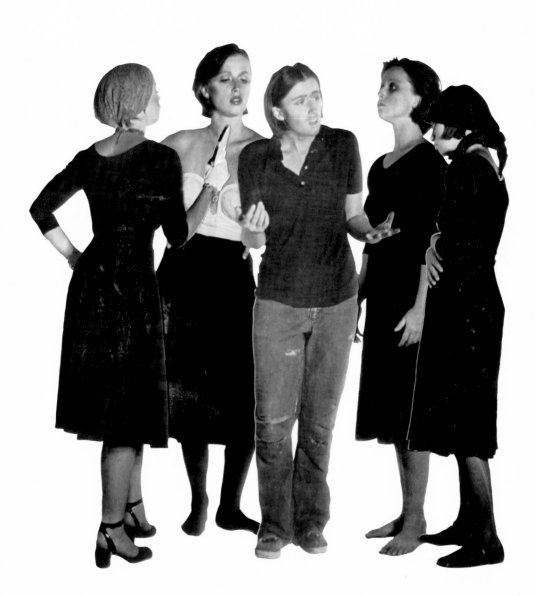

ACT 3 – 7

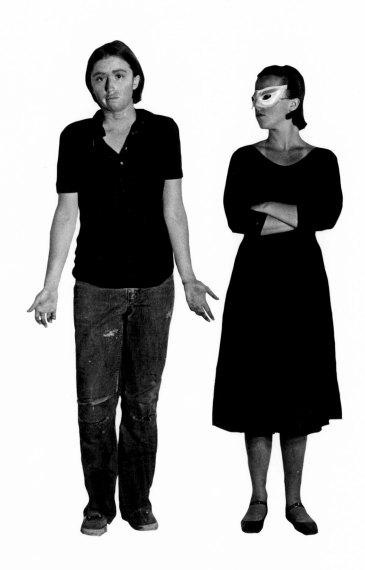

ACT 3 – 8

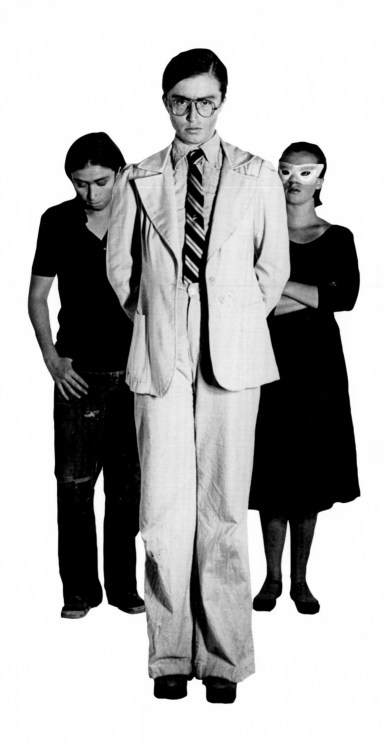

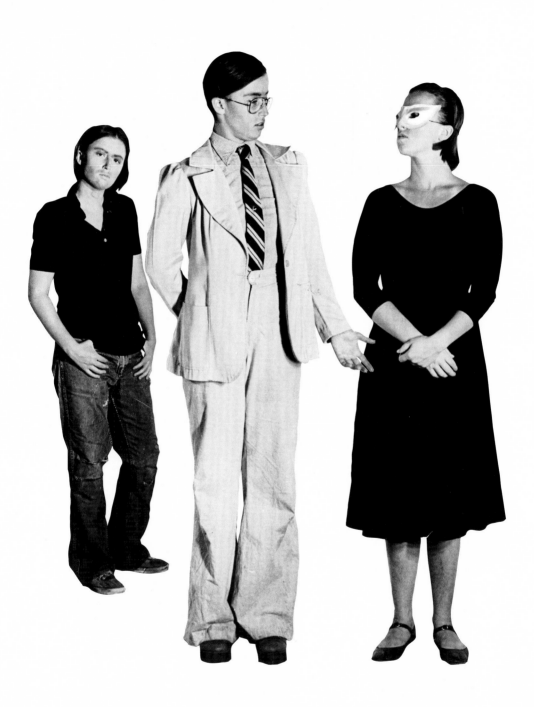

ACT 3 – 10

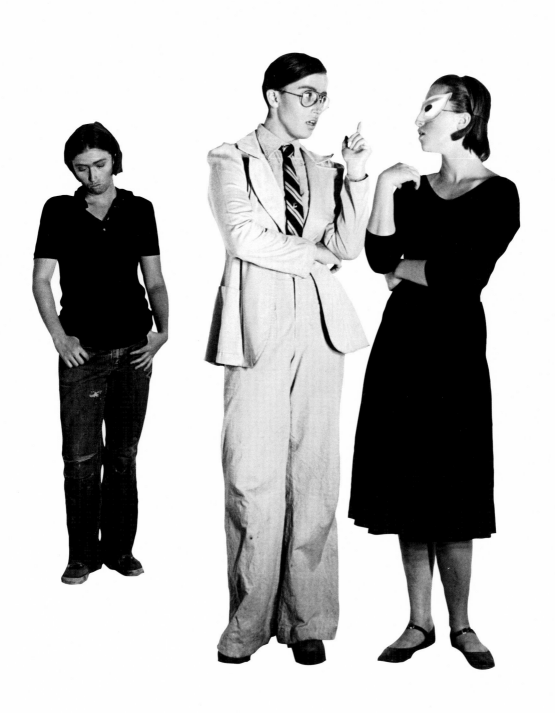

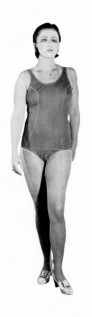

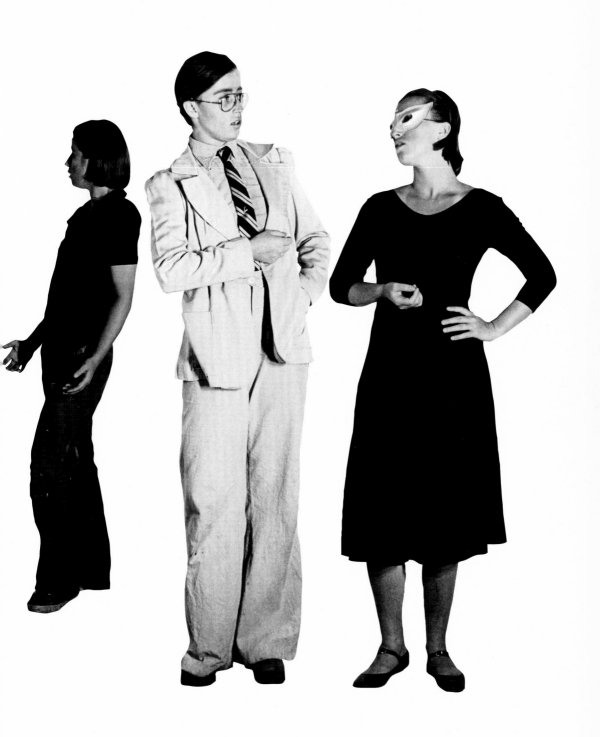

ACT 3 – 12

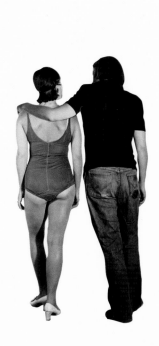
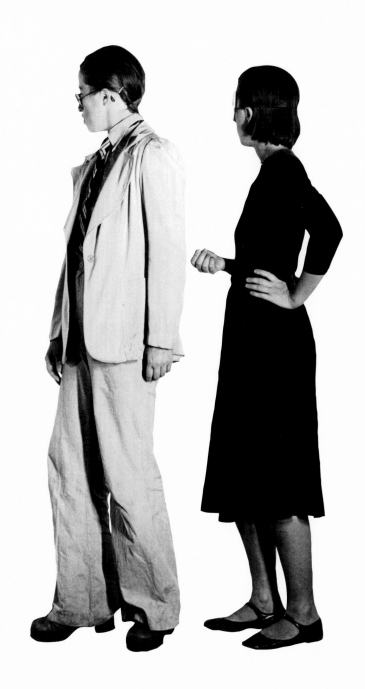

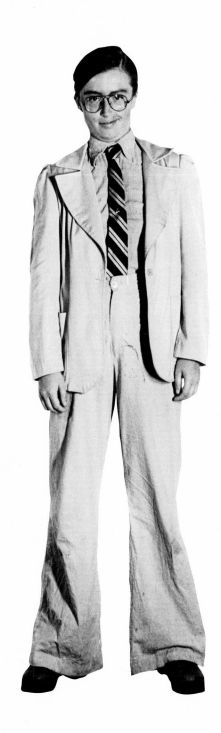

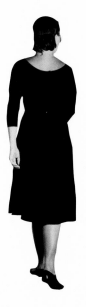

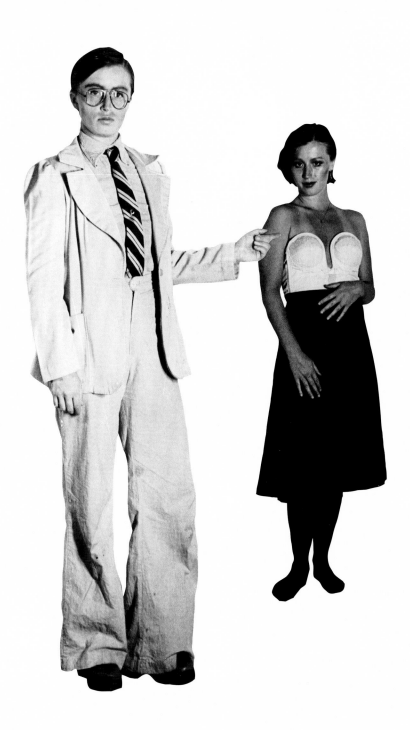

ACT 3 – 15

ACT 3 – 16

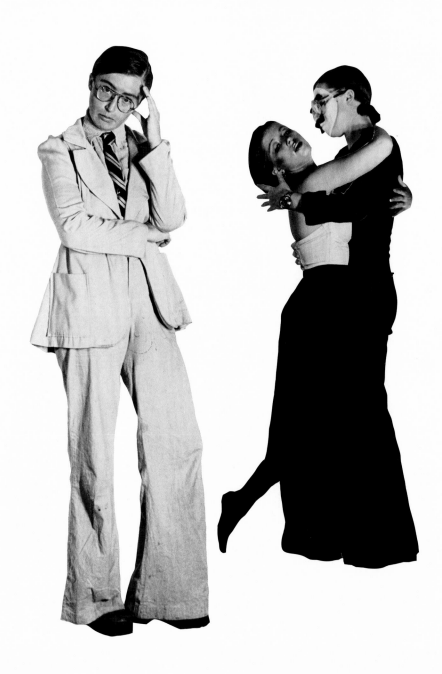

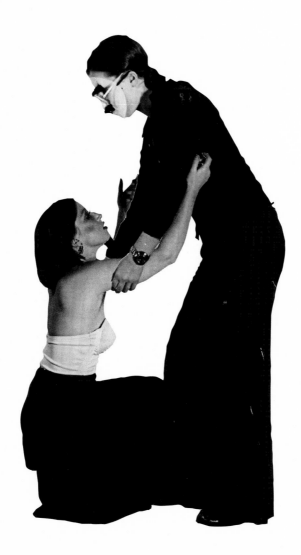

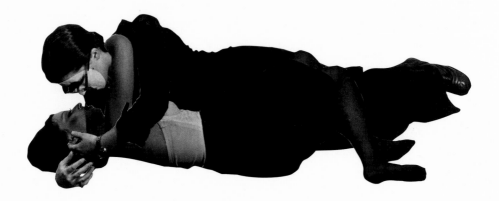

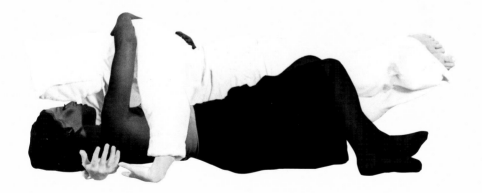

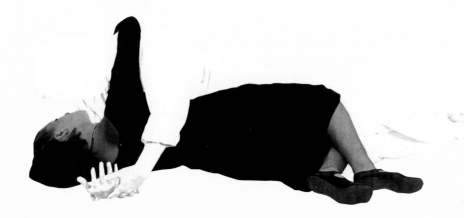

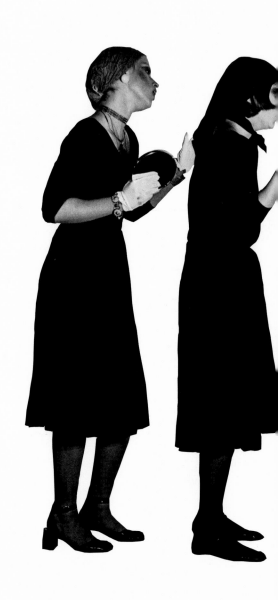

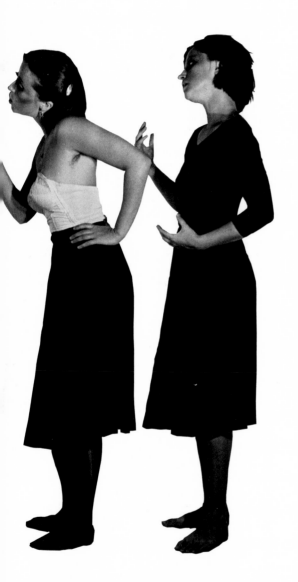
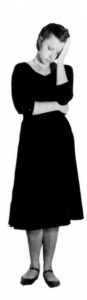

ACT 4 – 1

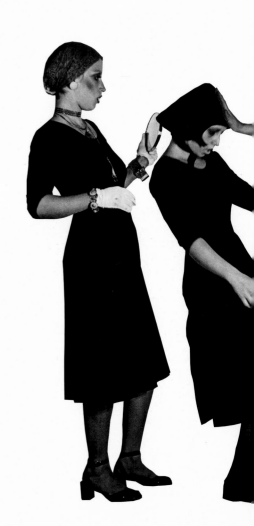

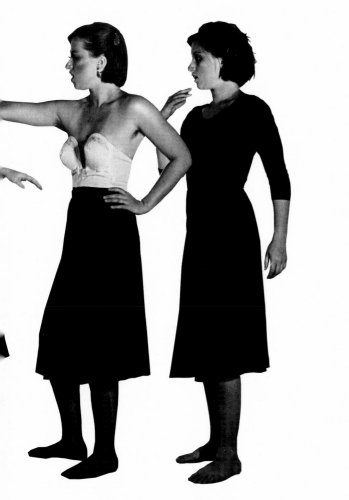
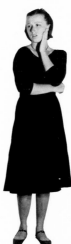

ACT 4 – 2

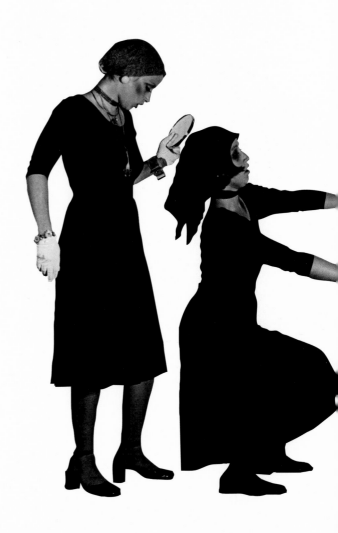

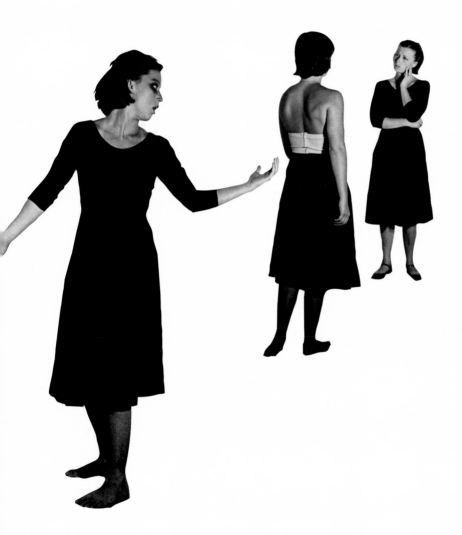

ACT 4 – 3

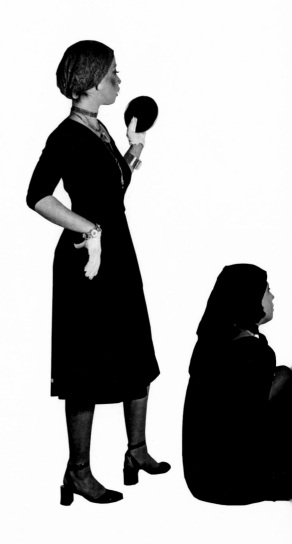

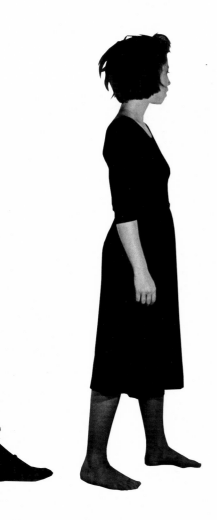
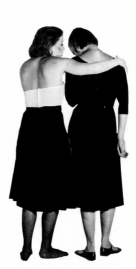

ACT 4 – 4

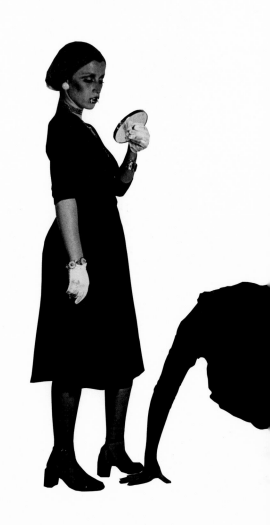

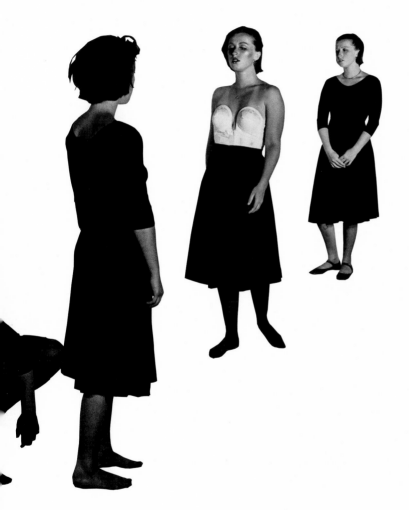

ACT 4 – 5

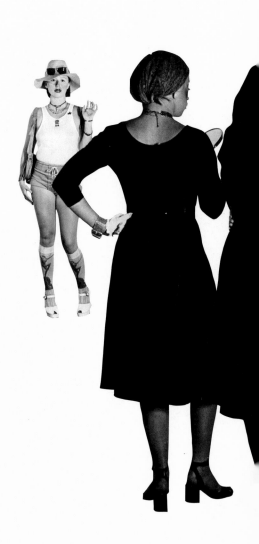

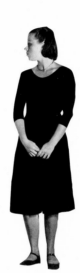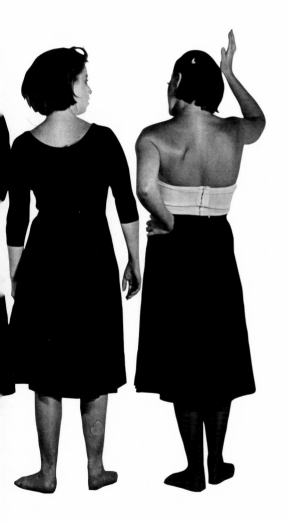

ACT 4 – 6

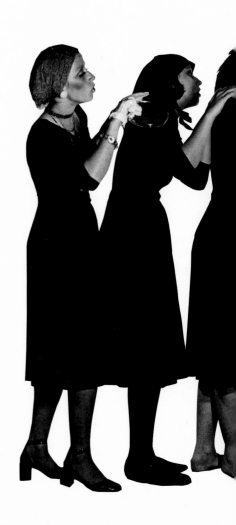

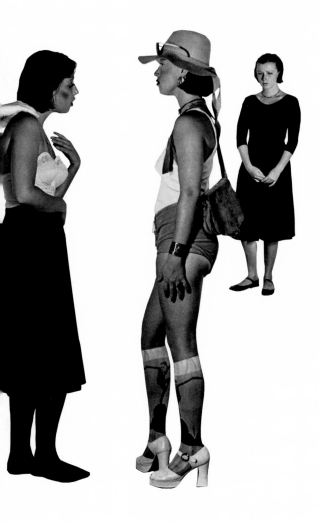

ACT 4 – 7

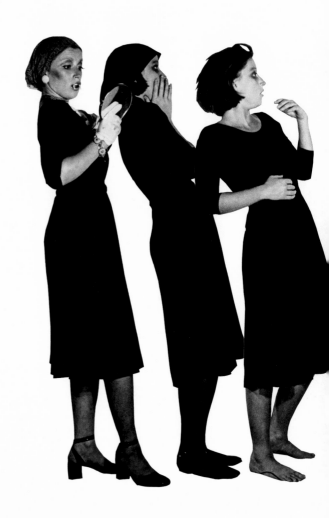

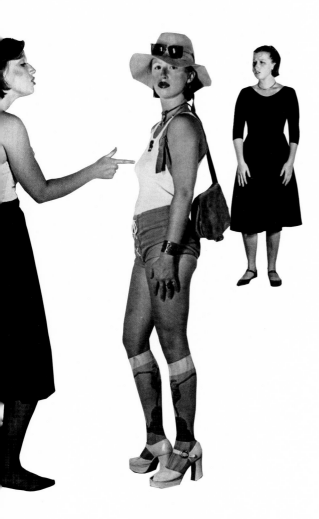

ACT 4 – 8

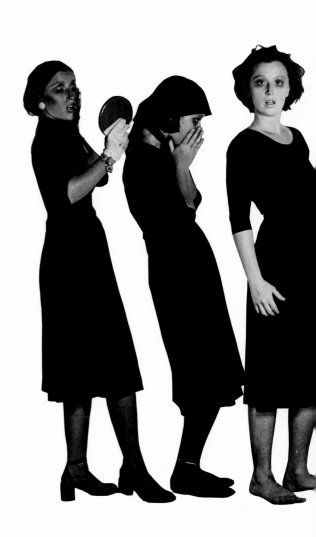

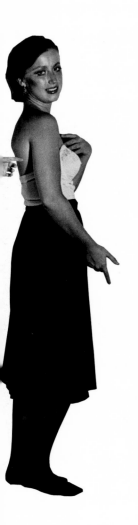

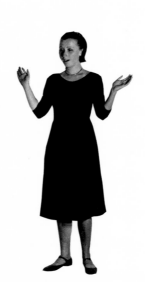

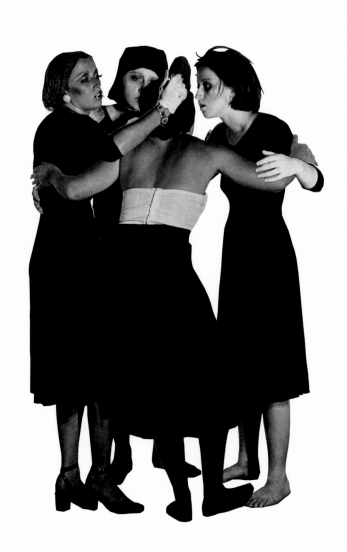

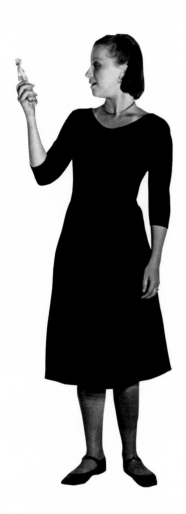

ACT 4 – 10

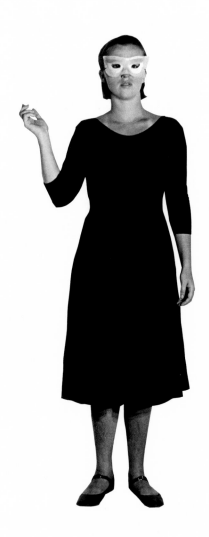

ACT 4 – 11

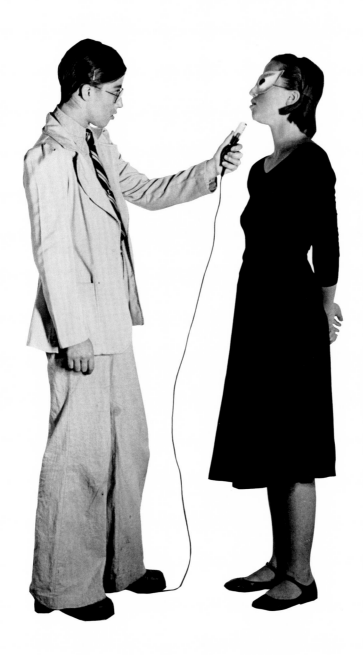

FINALE – 1

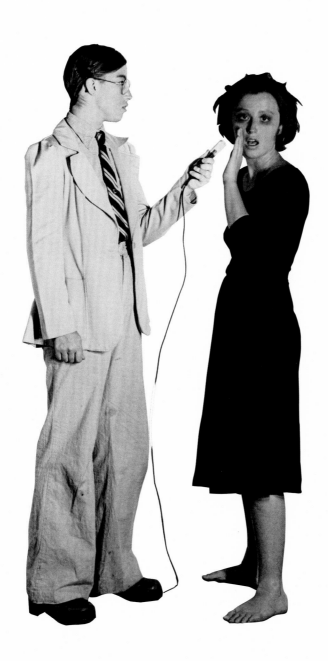

FINALE – 2

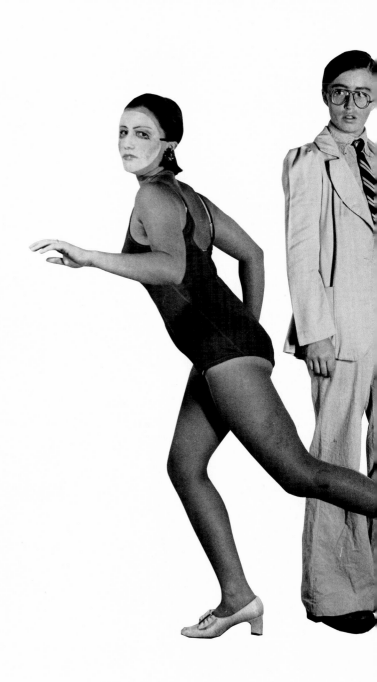

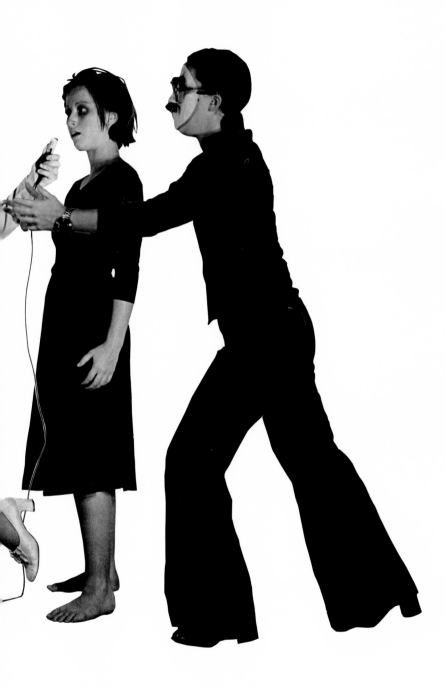

FINALE – 3

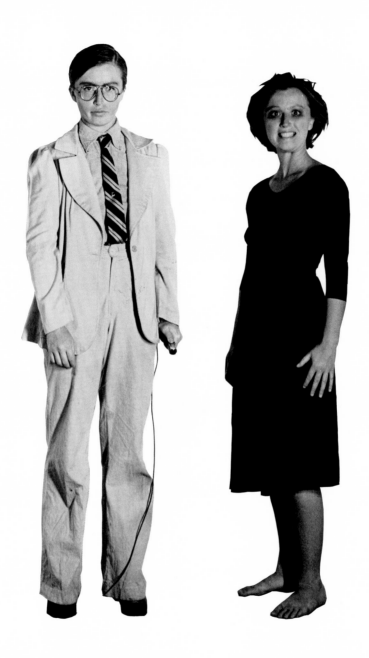

FINALE – 4

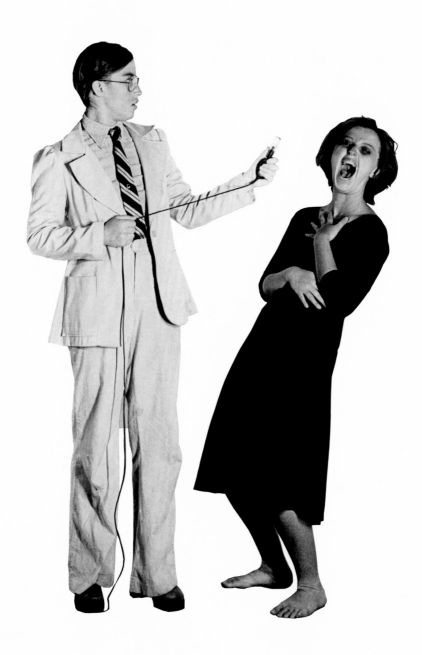

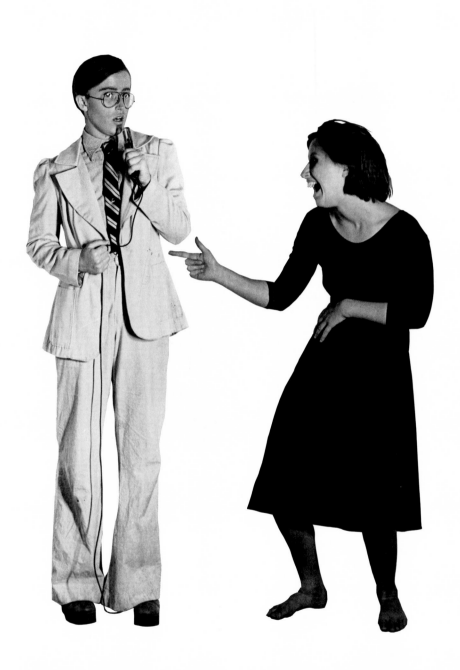

FINALE – 6

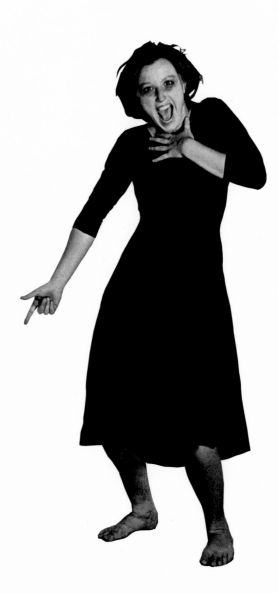

FINALE – 7

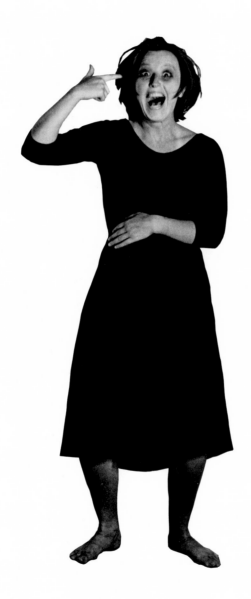

FINALE – 8

Scriptnotes
for
A Play of Selves

The Characters

A Broken Woman – the main character; sad and confused
(as she sees herself)

The Vanity – (ego?)
the Madness – (id?) } sub-characters of the
The Agony – (superego?) main character
The Desire – (libido?)

The Actual Main Character – the woman as she really is;
the control

The Character as Others See Her – the woman as she is
known and expected
to be

The Ideal Woman – what is desired to be } characters
 } of the subjects
The Ideal Man – what is desired to posses } imagination

A Frivolous Young Woman – naïve and immature; more a figment
of the main characters imagination
than an actual individual

The Female Seducer/Seducee –
 } also characters of the
 } subject's imagination
The Male Seducer/Seducee –

The Male Lover – the unseen physical presence whose character
is nevertheless an effective one on everyone
else.

A Female Friend – the listener
 } consoling characters
A Male Friend – the talker

The Narrator – the objective

The First Act:

(1) The sub-characters are gathered, arguing. The Actual Main Character and the Character as Others See Her are flanking the Broken Woman, consoling her. The Ideal Woman and the Ideal Man are standing apart from this group, calmly observing.

(2) The Narrator appears and points behind him to the Broken Woman who is in the same position as before, alone.

(3) The Broken Woman stands in front of Vanity, Madness, Agony, and Desire with an ashamed expression on her face, with arms outstretched, shielding them.

(4) The Narrator points behind to the Male Lover.

(5) The Male Lover and the Broken Woman embrace, while Desire hovers over Broken Woman's shoulder, watching intensely.

(6) The Broken Woman pushes the Male Lover away. Desire, disappointed, is holding Broken Woman's shoulder. Vanity stands in background.

(7) The Actual Main Character takes Broken Woman's place. Vanity comes closer.

(8) Madness and Agony join to surround the Male Lover.

(9) Agony starts weeping.

(10) Madness points a finger at Male Lover as A Frivolous Young Woman appears behind.

(11) The Frivolous Young Woman comes closer as the characters (except Male Lover) turn to face her.

(12) The Frivolous Young Woman and Male Lover stand alone in same position.

(13) Side by side they stare at each other.

(14) The Ideal Man is now standing before the Frivolous Young Woman and the Ideal Woman is with the Male Lover.

(15) The Male Lover and Frivolous Young Woman look away and out to audience.

The Second Act:

1. The Narrator stands with outstretched arms between the Female Seducer/seducee and the Male Seducer/seducee.

2. The Narrator, alone, looks thoughtful.

3. The Ideal Man and Ideal Woman confront the Male Seducer/Seducee and the Female Seducer/Seducee as Madness approaches from distance with shocked look.

4. Madness, close now, stands between both Seducer/Seducees.

5. Broken Woman looks from behind Madness's shoulder while the Seducer/Seducees expose themselves (backs to audience).

6. Agony crouches as Actual Main Character comforts her.

7. Vanity assumes the same crouching position while Actual Main Character's hand is in air, surprized.

8. The Character as Others See Her is now crouching, biting nails, alone.

9. The Female Friend approaches from behind.

10. Female Friend taps Character as Others See Her on back, who jumps.

11. They stand and talk. Character as Others See Her points to Broken Woman in distance.

12. Character as Others See Her points in other direction where Ideal Woman stands in distance.

13. Vanity is now with Female Friend, looking at Ideal Woman who is closer.

14. Vanity and Ideal Woman confront in a fight as Female Friend observes.

13. Vanity is crumpled on the floor as Female Friend looks puzzeled.

14. Agony joins Vanity.

15. So do Desire and Madness as Female Friend raises arms toward group, head looking up.

The Third Act:

① the Character as Others See Her is on the floor.

② Male Friend approaches from distance.

③ Male Friend stoops down to help Character as Others See Her.

④ They stand. Madness is now looking violently at Male Friend.

⑤ Male Friend seems to be explaining something while Agony also looks on.

⑥ Vanity and Desire appear on the other side, all mad looking.

⑦ They begin to close in on him.

⑧ He stops talking and the Actual Main Character is left standing next to him.

⑨ the Narrator is now in front of them, looking stern.

⑩ The Actual Main Character joins the Narrator as Male Friend stays in background.

⑪ They seem to be commenting on something to the audience and to each other.

⑫ the Ideal Woman comes into distance towards Male Friend.

⑬ Male Friend and Ideal Woman walk off together and Narrator and Actual Main Character watch.

⑭ Actual Main Character disappears in distance, too. Narrator smiles.

⑮ Narrator points to Desire.

⑯ Ideal Man stands next to Desire who smiles.

⑰ They embrace. Narrator looks embarrassed.

⑱ Desire pulls Ideal Man down to ground. Narrator is gone.

⑲ They are lying side by side in each other's arms.

⑳ Ideal Man turns into Male Lover.

㉑ Desire turns into Broken Woman.

The Forth Act:

1. Agony and Desire are arguing. Vanity is pleading with Agony to stop while Madness does same with Desire. Broken Woman is in background.

2. Desire pushes Agony.

3. Agony falls down as Desire walks over to Broken Woman.

4. The others watch while Desire speaks comfortingly to Broken Woman.

5. The Broken Woman is watching, still in distance. Desire is returning to her peers. Agony is standing up.

6. The four sub-characters are standing close together with backs to audience. Desire is waving to the Frivolous Young Woman who is approaching.

7. The Frivolous Young Woman is standing next to Desire talking to her. Agony, Madness and Vanity are leaning over each other's's shoulders.

8. Desire points a finger at Frivolous Young Woman who turns to look at audience. Everyone else looks tense.

9. Frivolous Young Woman has turned into a little doll. Broken Woman looks happy.

10. Broken Woman is holding doll. Desire and friends are huddled.

11. Broken Woman becomes Actual Main Character.

Finale:

① Narrator is interviewing <u>Actual Main character</u>.

② <u>Madness</u> faces and whispers something to audience.

③ The <u>Ideal woman</u> runs in front of them with <u>Ideal Man</u> chasing after her.

④ <u>Narrator</u> looks perturbed. <u>Madness</u> smiles wickedly.

⑤ <u>Madness</u> laughs hysterically.

⑥ <u>Madness</u> points a finger at <u>Narrator</u>.

⑦ <u>Narrator</u> turns into little doll. <u>Madness</u> still laughs.

⑧ <u>Madness</u> points finger at head.

end

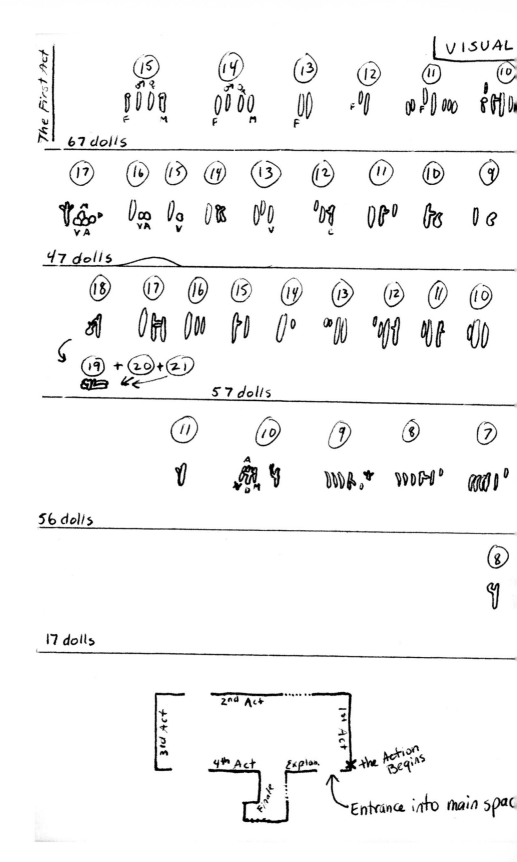

124

The First Act

VISUAL

67 dolls

47 dolls

57 dolls

56 dolls

17 dolls

3rd Act 2nd Act 1st Act

4th Act Explan. ✱ the Action Begins

Finale

↑ Entrance into main spac

© 1976 cindy Sherman

01076240

CINDY SHERMAN
A PLAY OF SELVES, 1975
Black-and-white photographs mounted on board (72 parts)
Schwarz-Weiß-Fotografien auf Pappe (72 Teile)

Act 1 : Scene 1	- 15 × 21 ¾ inches	Act 3 : Scene 6 - 15 × 17 ¼ inches
Act 1 : Scene 2	- 15 × 13 ¾ inches	Act 3 : Scene 7 - 15 × 11 inches
Act 1 : Scene 3	- 13 ¼ × 10 inches	Act 3 : Scene 8 - 15 × 10 ½ inches
Act 1 : Scene 4	- 15 × 11 ¾ inches	Act 3 : Scene 9 - 15 × 11 ½ inches
Act 1 : Scene 5	- 15 × 9 ¾ inches	Act 3 : Scene 10 - 15 × 14 ¾ inches
Act 1 : Scene 6	- 15 × 16 inches	Act 3 : Scene 11 - 15 × 14 ½ inches
Act 1 : Scene 7	- 15 × 17 inches	Act 3 : Scene 12 - 15 × 19 inches
Act 1 : Scene 8	- 15 × 20 inches	Act 3 : Scene 13 - 15 × 16 ¼ inches
Act 1 : Scene 9	- 15 × 20 inches	Act 3 : Scene 14 - 15 × 11 ¼ inches
Act 1 : Scene 10	- 15 × 20 ¾ inches	Act 3 : Scene 15 - 15 × 11 ½ inches
Act 1 : Scene 11	- 15 × 20 ¼ inches	Act 3 : Scene 16 - 15 × 14 ¼ inches
Act 1 : Scene 12	- 15 × 9 inches	Act 3 : Scene 17 - 15 × 13 inches
Act 1 : Scene 13	- 15 × 10 inches	Act 3 : Scene 18 - 15 × 10 ¼ inches
Act 1 : Scene 14	- 15 × 12 ½ inches	Act 3 : Scene 19 - 15 × 13 ½ inches
Act 1 : Scene 15	- 15 × 14 inches	Act 3 : Scene 20 - 15 × 13 inches
Act 2 : Scene 1	- 15 × 13 inches	Act 3 : Scene 21 - 15 × 14 inches
Act 2 : Scene 2	- 15 × 17 ¾ inches	Act 4 : Scene 1 - 14 ¼ × 17 ¼ inches
Act 2 : Scene 3	- 15 × 22 inches	Act 4 : Scene 2 - 14 ½ × 19 ½ inches
Act 2 : Scene 4	- 15 × 15 ¾ inches	Act 4 : Scene 3 - 14 ½ × 19 ½ inches
Act 2 : Scene 5	- 15 × 19 ¼ inches	Act 4 : Scene 4 - 14 ½ × 19 ½ inches
Act 2 : Scene 6	- 15 × 9 ¼ inches	Act 4 : Scene 5 - 14 ½ × 19 ½ inches
Act 2 : Scene 7	- 15 × 9 inches	Act 4 : Scene 6 - 14 ½ × 19 ½ inches
Act 2 : Scene 8	- 15 × 8 inches	Act 4 : Scene 7 - 14 ½ × 19 ½ inches
Act 2 : Scene 9	- 15 × 12 inches	Act 4 : Scene 8 - 14 ½ × 19 ½ inches
Act 2 : Scene 10	- 15 × 10 ¼ inches	Act 4 : Scene 9 - 14 ½ × 19 ½ inches
Act 2 : Scene 11	- 15 × 11 ¾ inches	Act 4 : Scene 10 - 14 ½ × 19 ½ inches
Act 2 : Scene 12	- 15 × 11 ¼ inches	Act 4 : Scene 11 - 14 ½ × 13 inches
Act 2 : Scene 13	- 15 × 11 ¾ inches	Finale : Scene 1 - 14 ½ × 13 inches
Act 2 : Scene 14	- 15 × 11 ½ inches	Finale : Scene 2 - 14 ½ × 13 inches
Act 2 : Scene 15	- 15 × 13 ½ inches	Finale : Scene 3 - 14 ½ × 21 ½ inches
Act 2 : Scene 16	- 15 × 15 inches	Finale : Scene 4 - 14 ½ × 13 inches
Act 2 : Scene 17	- 15 × 16 ¼ inches	Finale : Scene 5 - 14 ½ × 13 inches
Act 3 : Scene 1	- 15 × 10 ¼ inches	Finale : Scene 6 - 14 ½ × 13 inches
Act 3 : Scene 2	- 15 × 12 ½ inches	Finale : Scene 7 - 14 ½ × 13 inches
Act 3 : Scene 3	- 15 × 10 ¾ inches	Finale : Scene 8 - 14 ½ × 13 inches
Act 3 : Scene 4	- 15 × 10 ¼ inches	
Act 3 : Scene 5	- 15 × 11 ¾ inches	

This book is published by Hatje Cantz Verlag in collaboration with Metro Pictures, New York, and Sprüth Magers, Cologne / Munich / London

Diese Publikation erscheint im Hatje Cantz Verlag in Zusammenarbeit mit Metro Pictures, New York, und Sprüth Magers, Köln / München / London

Edited by / Herausgegeben von Metro Pictures, New York, Sprüth Magers, Cologne / Munich / London

Copyediting / Verlagslektorat: Simone Albiez, Tas Skorupa

German translation / Deutsche Übersetzung: Stefan Barman

Graphic design / Grafische Gestaltung:
www.hackenschuh.com, Martin Grether, Stuttgart

Typeface / Schrift: Aaux Pro

Paper / Papier: Luxosamt Offset 150 g/m²

Binding / Buchbinderei: Verlagsbuchbinderei Dieringer, Gerlingen

Reproductions and printing / Reproduktion und Gesamtherstellung:
Dr. Cantz'sche Druckerei, Ostfildern

Published by / Erschienen im
Hatje Cantz Verlag
Zeppelinstrasse 32
73760 Ostfildern
Germany
Tel. +49 711 4405-200
Fax +49 711 4405-220
www.hatjecantz.com

Hatje Cantz books are available internationally at selected bookstores and from the following distribution partners:

USA/North America – D.A.P., Distributed Art Publishers, New York, www.artbook.com
UK – Art Books International, London, www.art-bks.com
Australia – Tower Books, Frenchs Forest (Sydney), www.towerbooks.com.au
France – Interart, Paris, www.interart.fr
Belgium – Exhibitions International, Leuven, www.exhibitionsinternational.be
Switzerland – Scheidegger, Affoltern am Albis, www.ava.ch

For Asia, Japan, South America, and Africa, as well as for general questions, please contact Hatje Cantz directly at sales@hatjecantz.de, or visit our homepage at www.hatjecantz.com for further information.

ISBN 978-3-7757-1942-1

Printed in Germany

Cover illustration / Umschlagabbildung: ACT 3 – 9